Silence

I think it's time for us to take a moment of silence
for every moment of violence.
Let us raise our first for all the Mike's and the Trayvon's
and the young black men that are being killed because there's melanin in their skin..
We need a moment of silence.
Let us take a second to acknowledge that all lives matter.
That all. lives. matter.
But not the black lives that are shattered that are scattered that are battered..
So let us take a second to realize that the real lie is that NOT all lives matter.
Not the black mothers and black fathers,
black sons and black daughters.
They have no place in this world with white problems and white founders.
They're just brown coins in white fountains, brown dreams on white mountains,
brown things with white announcements begging them brown silence.
Begging them closed eyes and closed minds and no violence.
We need y'all to stop this war on Black America.
We ain't even ask to be here, we just stayed put because you kept us.
We ain't ask to consume communion, we just ate the lies that you fed us,
And I'm tired of being quiet and compliment, just to get yo bread up.
I'm tired of people dying
And white privilege being denied
And no black faces occupying the spaces placed to find your mind in.
Sometimes you gotta close both eyes to see clear.
Sometimes you gotta steal awake because peaceful sleep can breed fear.
Sometimes you gotta March with signs because peaceful streets are not here.
And sometimes you gotta resort to violence because peaceful hands don't breed ears that listen.
We. Are. Crying.
Shouting for no violence
and counting on no silence.

They Ask Me Why Eye Love Her

She be BLACK
She be BLACK, she be Queen
BLACK, she be Queen, she be God
She be skin
Finger tips against my skin
She be finger tips against my skin, she be sensation
Elevation
She be no hesitation just relaxation
Just chill
She be chill, she be cool
Cause she be BLACK
Aka RED
Aka RED. BONED.
She be the red between my bones
She be my rib
She be safe haven
Home
She be
Teacher, preacher, leader
Cause she be BLACK
She be the reason you exist
She be life
She be lines
She be life lines
She be heartbeat
She be bongos on a Summer day
Like bongos on a Summers day, she be melody
She be music
She be poetry
She be creation
Restoration
Don't forget who birthed you
She be life to this nation
And yet you ask me why Eye love her
Like you ain't just witness black greatness

Running

"You know, I wonder if they'll laugh when I am dead.. Why am I fighting to live, if I'm just living to fight? Why am I trying to see, when there ain't nothing in sight? Why am I trying to give, when no one gives me a try? Why am I dying to live, if I'm just living to die?"

Imagine a world where black babies become something other black bodies on black pavement.
Imagine graduations.
Not mothers buddying sons,
but boys becoming men-men becoming fathers.
Imagine a world where Geneva Reed-Veal never had to lose her daughter.
In school they only teach you one thing.
They teach you that humans only come in white skin, but I am here to teach you about the original packaging.
Back before the beatings and the slavery,
back before human trafficking.
So open up your eyes and stay hip to what's happening.
Stay hip to the savaging.
Stay hip to the ravaging.
Stay hip to the tools that they used to dismantle this.
They be preachin that "Everybody is afforded the same opportunities" shit
That "Worry about black crime in the black community" shit.
I watched a video on Facebook one day and when asked what he wanted to be when he grew up, be replied "Alive".
Government designed to try to keep niggas in line.
Got officers killin kids, but they just don't call it crime.
They create the problem and then turn it into mine.
But imagine growin old.
Imagine being free able to grow into your soul.
Because sometimes you gotta place yourself in freedom on your own.
And instead of asking why you're living, ask the universe to grow.

Limited

Let's talk about the system of America's education.
Taught to disregard enslavement, manipulative.
Sidewalks become paper, black bodies be endangered.
No boys becoming men, triggers used to erase us.
Figures used to sedate us.
Religion to recreate us.
Yet every school book says Lincoln stood up to save us.
They say shit like "As long as you follow the law and educate yourself, you will have a good life."
Same thing Philando mother probably said before they took his life.
Death over traffic violations, if you black not white.
There will never be a limit while I fight this fight.

Alarm (Haiku)

Being black is like
Pressing snooze on the fact that
Not all lives matter

Surname

Black girl afraid to give birth to black boy
Black boy afraid to give black girl world
Black world afraid to give black child a name that they can live up to

I'm tired of being teased for having a "white" name

Black girl that comes from the hood,
never up to no good,
got head in them books because she wanna be somebody.

Got the name of a valley girl
But really, she from the city where they'd leave your heart in a alley girl
So don't judge a book by its cover

My Negus

"My nigga my nigga,
My nigga my nigga.
My nigga my nigga,
My muhfuckin nigga."

All my niggas be queens.
All my niggas be rich.
All my niggas be Gods.
All my niggas be sick and tired of complying and still dying.
All my niggas?
We just out here tryna survive
and break bread to feed our tribe,
and Babylon fears us because they know we on the rise.
All my niggas got energy light enough to fly.
Root chakra connected to the earth because it's mine...
I mean it's ours.
All my niggas got scars.
Battle wounds that prove that we will never back down to the sound of the red white and blue,
just stay true to I & I and the moon.
All my niggas, we on the move.
On the up and up.
Fuck throwin our hands up cause we ain't the ones who messed up.
Told to stay in line by the same people who won't fess up for killin us.
All my niggas can't trust no pig
that's just tryna make they quota,
and then act like they told you to comply and you'll live,
when we all know they'd shoot you quick as a ticket they wrote ya.
All niggas is soldiers.
Screaming "FUCK THE POLICE"
we takin over these streets,
can't no tear gas take us off our feet
nor off our toes.
All my niggas is pros.
Suit and tie,

we graduated from the hood.
Stand tall for those who can't but wish they could.
Graduated from the projects
to the good live of being projected by those carrying shoulddas, coulddas, woulddas.
All my niggas, we fooled ya.
Into thinking the white man can keep us down when he can't.
Tellin is comply yet we still here in they face.
We are the chosen generation,
here to protect what they can't.
All my Negus be Gods, so fuck y'all niggas who ain't.

Freedom

Free who?
Free what?
Free them.
Free us.

I'm from a city that needs freedom,
a city that never sleeps.
A city that lines the news with palm trees and concrete.
I am from a city where
souls are sold to slavery.
Where mammas help babies push out babies.
Where "Maybe" 's become "Girlllll, he aint even been around lately."

We grow up with teachers with no respect,
with children who learn neglect
from parents that work double shifts,
just to spend that paycheck on a nigga who could care less.

We forget that the steal frame inside of our minds
is what causes us to think that these streets give a fuck about that child with no father.
About that young man who will no longer be able to hold his 6 month old son in his arms,
due to the compassion that skips over the head of every youth born into my generation.

I'm from a city where young girls wear short shirts
and let men slide into their bodies,
because they truly believe that
"Giving a man what they got to get what they want"
is all they have to look forward to to make it in this twisted society.

I am from a city that needs freedom.

I'm from a city where theres more crack rocks and botox than life lines,
so life knocks down the door of every 16 year old boy in the form of a gun.
A city where gang bangin and block hangin are credentials for graduating
with a full ride to the next juvenile facility where a 13 year old boy shot and killed a mothers son
to complete his gang initiation.

The city that I'm from, we need freedom.

We need to fund books, not fund crooks that sell dope in these streets
and prevents my community from functioning properly.
We need to get these guns out these parks
and bring these assassins from the dark
and expose the government for who they really want to be,
and not for just who they are.

We need to take the word "single" from "mother",
we need to reach goals with this hunger.
And realize that the depletion of another court date can be the beginning of our future.

I am from a city that needs freedom.

I'm from a city where children misidentify their fists as words.
A city where women are treated like birds,
and three year old babies sleep below the window to escape the bullets above the curb.

A city where women are eaten alive form the inside out,
where people are born a statistic with no doubt
in their hearts that this life that they are living is freedom.

Freedom is NOT this natural disaster of a life that you're living.
It aint just red rags and blue flags that represent some block that'll
keep breathing with the oxygen that it stole from your limp body.
Freedom aint just two bodies sharing one soul
when really only one body wants to be involved because in her mind,
she thinks that he'll still love her tomorrow.

We need freedom.

We need tongues to spit more knowledge,
thugs to go to college.
Niggas to become Kings and quit holding their Queens hostage.

We need freedom, freedom, freedom.
We need freedom, freedom, freedom.

The city that I'm from, we need freedom.

Rooted

Be strong black woman
each scar of defeat is what
lifts you up again

Ebonics

They say that telekinesis is non fiction,
yet here we are speaking a language that
doesn't even depend on words

Separate But Not Equal
(a biracial love story)

I listened to each painful memory and I
replaced it with everything that I knew to be happiness.
I wiped away each sorry and I reassured you that not one tear
fell upon ears that did not care to pay attention.
You were afraid.
Darkness descends down on what was once considered stability,
and each palpitation of your heart grows because you fear being left behind.
Do not run from who has take you away to a place where hurt does not exist.
Lying in the depths of each memory, with the rest of reality living with eternal enemies.
I am the the only road that leads to free.
To a better love.

Mental

I am the type that believes in salvation, more than I believe in life.
I believe in moving on,
detouring aspects of yourself
that you didn't even know existed.
Reaching for things,
trying again even though you
missed it.
Breaking down barriers..
Walls have been built,
but pride has just dismissed it.
I am the type that believes in salvation, more than I believe in life.
I believe in miracles,
because I think that if you
believe hard enough,
your beliefs will save everyone.
But they won't.
Beliefs will not be the token you
need to heal the
broken.
I am the type that believes in salvation, more than I believe in life.
I believe in a souls shine.
I believe in words..
hands being connected with
pens that have reflected
my sins.
I believe in worth.
The pain of your past is
so severe that you go outside
just to feel the mist kiss
your skin,
because you're hurt.
You spend hours in the cold,
the clouds covering you whole..
I believe in Earth.
As her daughter,
automatically I am put on her
list of protection.
Storms may come,
but the brightness of the Sun
is perfection.
I love the fact that my
mother has a mind of ones own.
A crown that's forever glown..
I believe in Her.
I am the type that believes in salvation, more than I believe in life.

And I believe in you

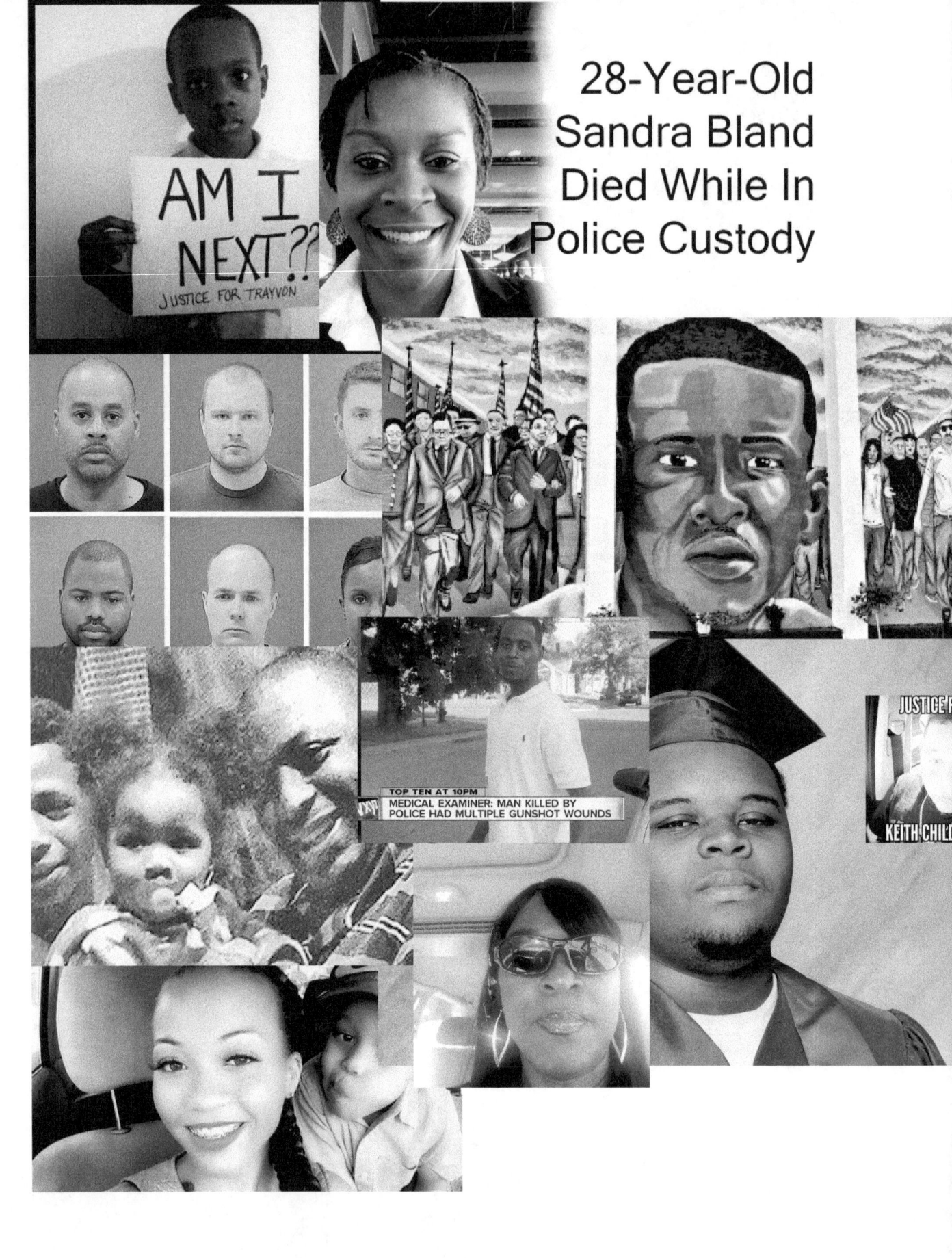

28-Year-Old Sandra Bland Died While In Police Custody

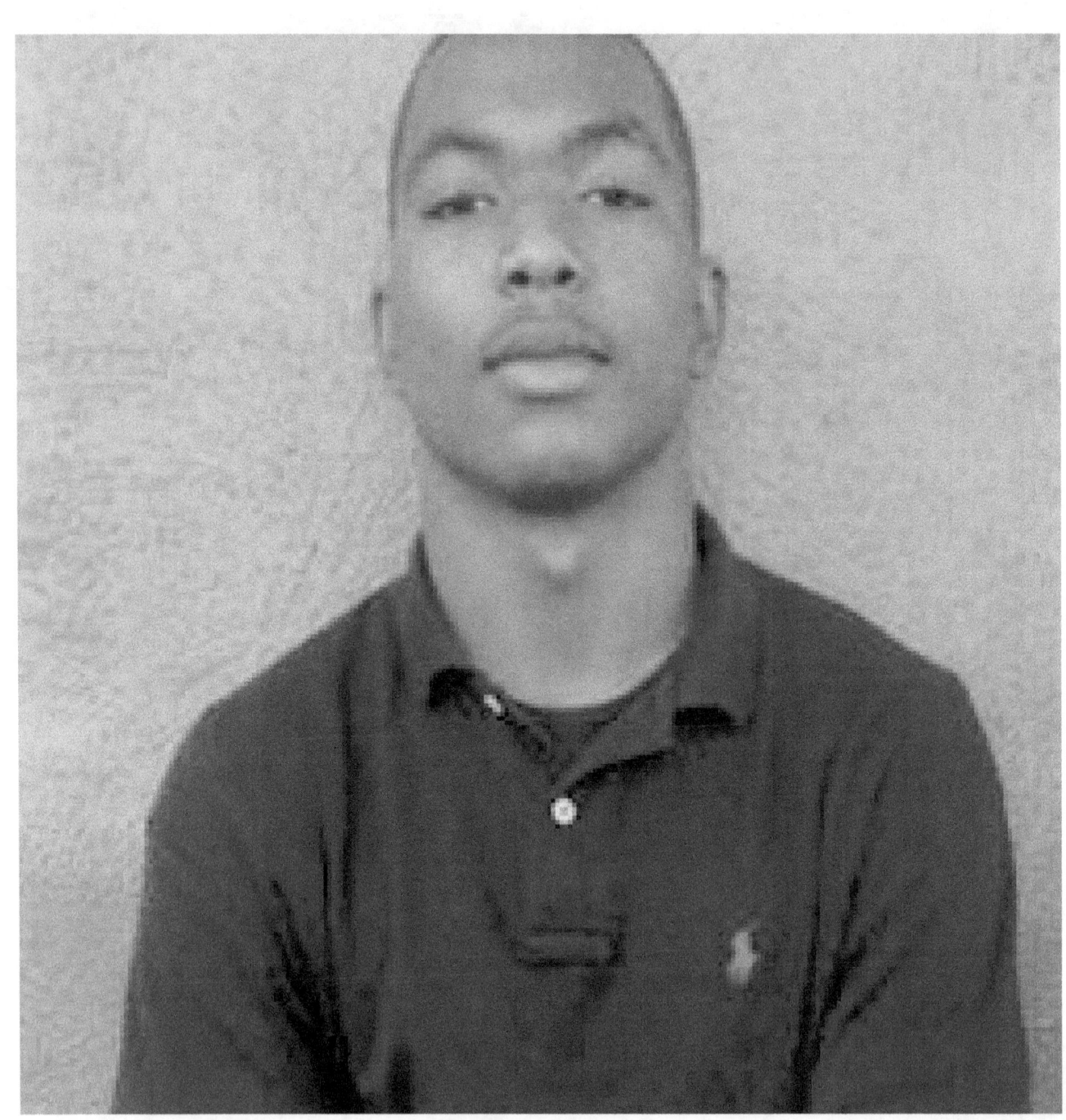

BLACK LIVES MATTER

The Color Me Human series is for those who understand what it means to live with skin that has no privilege. Thank you for reading.

Here's my information. I'm very personable and stuff.

Instagram/Twitter: @__SunflowerMo
Facebook: Sunflower Mo, Author (@ghettosun)
Email: sunflower.mo.7@gmail.com

Just in case you're feeling inspired...

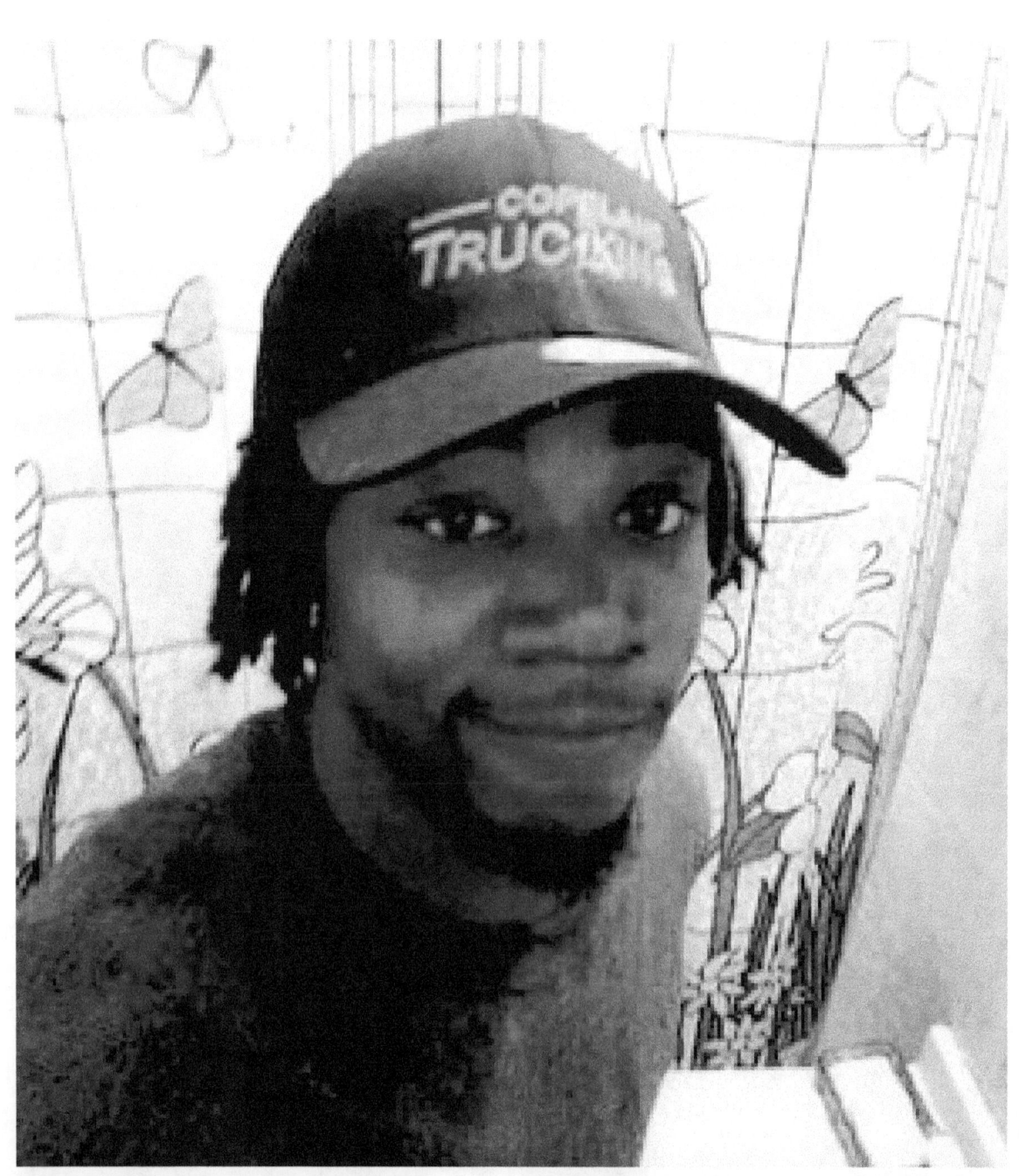

www.ingramcontent.com/pod-product-compliance
Lightning Source LLC
Chambersburg PA
CBHW080645190526

45169CB00009B/3515